E
TIB Tibo, Gilles.

Simon says.

32910030049631

$17.95

DATE			

Simon Says:
Seasons

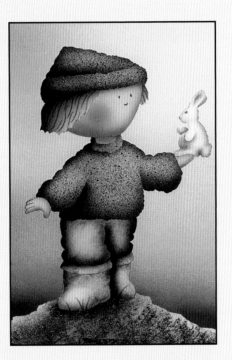

Simon Says:
Seasons

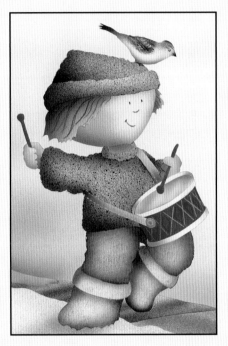

GILLES TIBO

TUNDRA BOOKS

Published in Canada by Tundra Books,
75 Sherbourne Street, Toronto, Ontario M5A 2P9

Published in the United States by Tundra Books of Northern New York,
P.O. Box 1030, Plattsburgh, New York 12901

Library of Congress Control Number: 2006902061

Library and Archives Canada Cataloguing in Publication

Tibo, Gilles, 1951-

[Quatre saisons de Simon. English]

 Simon says : seasons / Gilles Tibo.

Includes: Simon and the wind, Simon and the snowflakes, Simon
 welcomes spring and Simon in summer.

For ages 4-8.

ISBN-13: 978-0-88776-793-7
ISBN-10: 0-88776-793-1

 I. Title. II. Title: Quatre saisons de Simon. English.

PS8589.I26Q3813 2006 jC843'.54 C2005-907458-2

ONTARIO ARTS COUNCIL
CONSEIL DES ARTS DE L'ONTARIO

We acknowledge the financial support of the Government of Canada through the
Book Publishing Industry Development Program (BPIDP) and that of the Government
of Ontario through the Ontario Media Development Corporation's Ontario Book
Initiative. We further acknowledge the support of the Canada Council for the Arts
and the Ontario Arts Council for our publishing program.

Printed in China

1 2 3 4 5 6 11 10 09 08 07 06

To Marlène and Simon

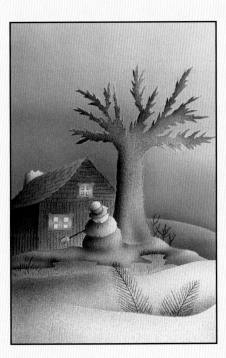

Simon
in Spring

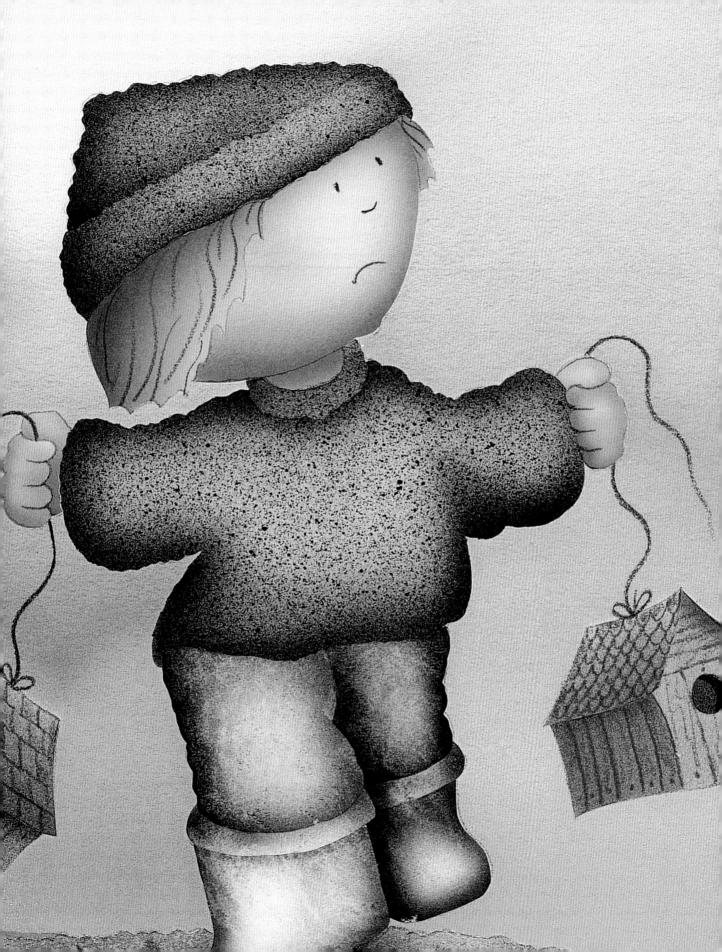

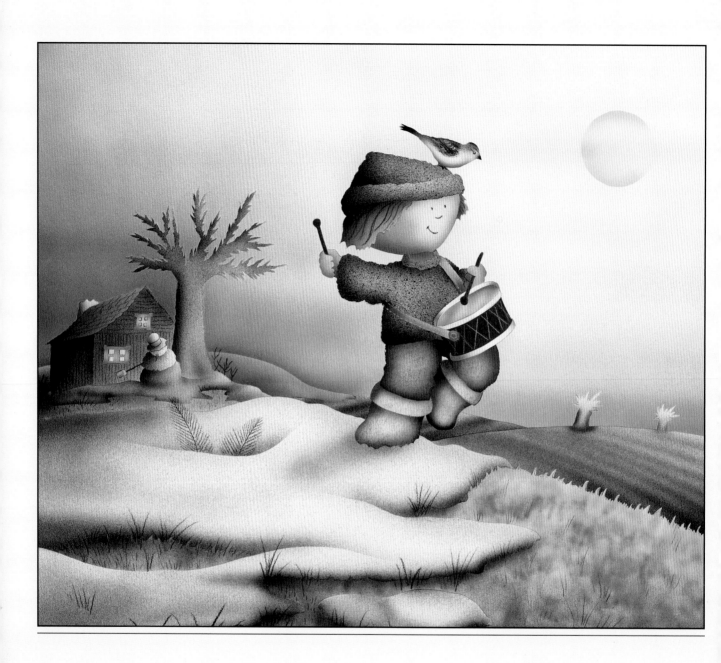

I love spring when the snow begins to melt.

I can play my drum outdoors.

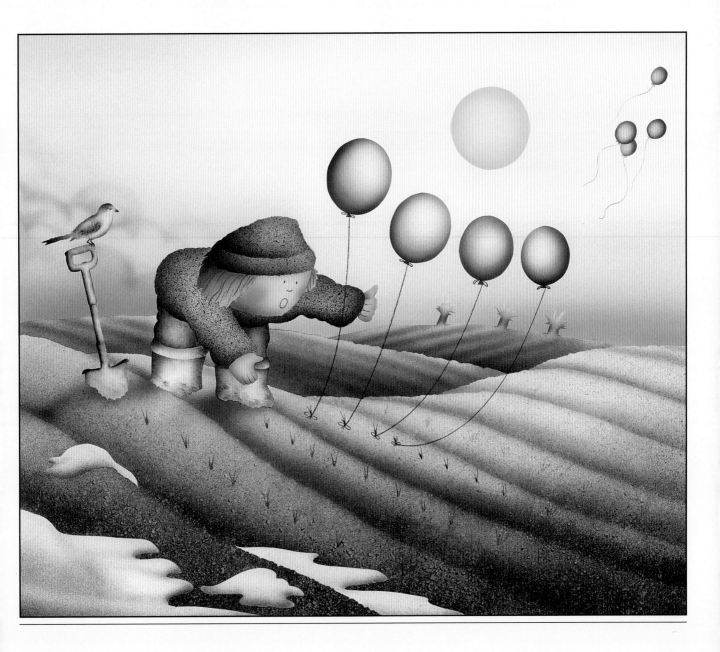

I can help the flowers grow.

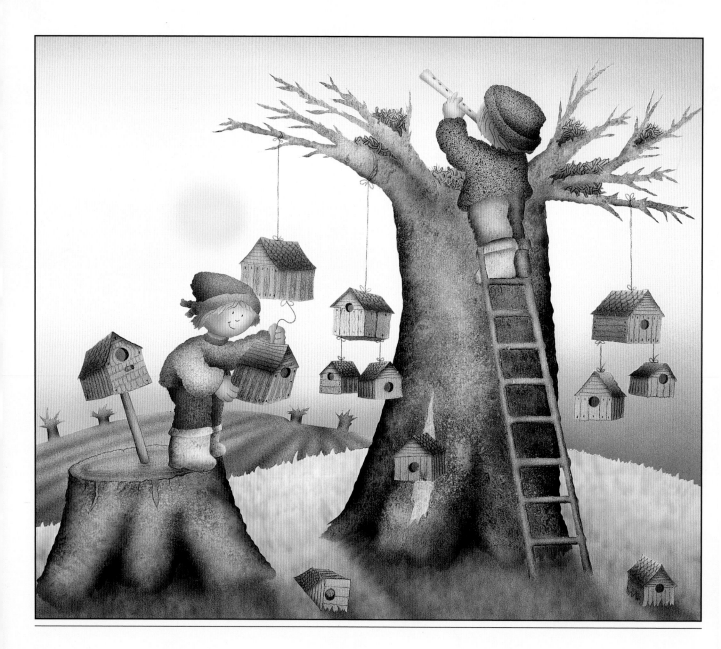

Marlene and I welcome the birds home.

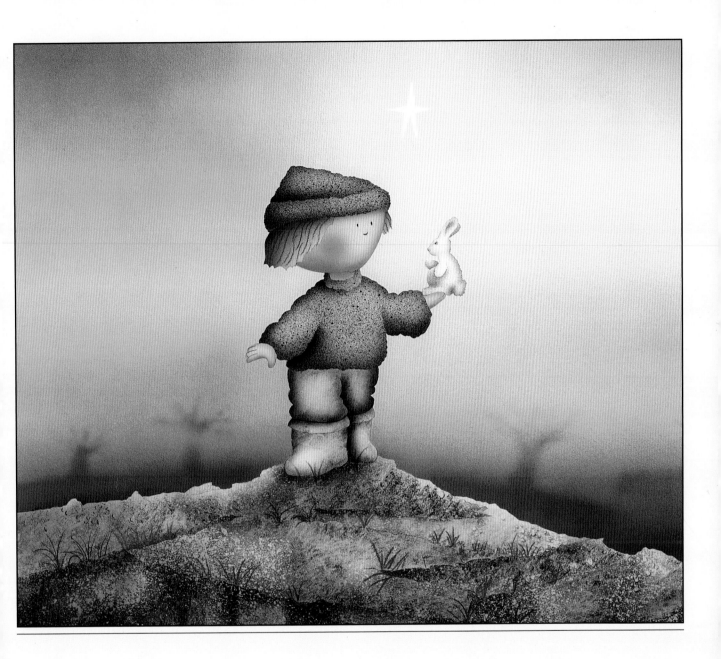

I wake the rabbit in a newly green field.

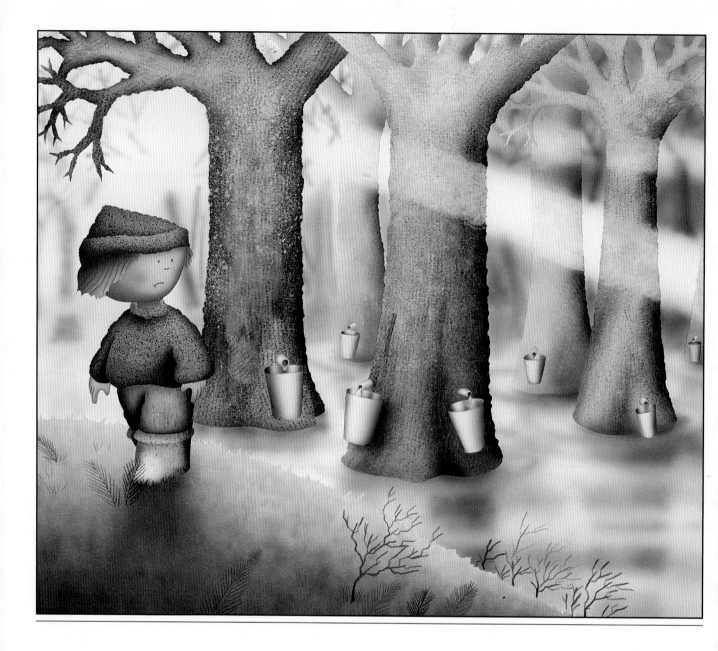

I gather sap from the woods.

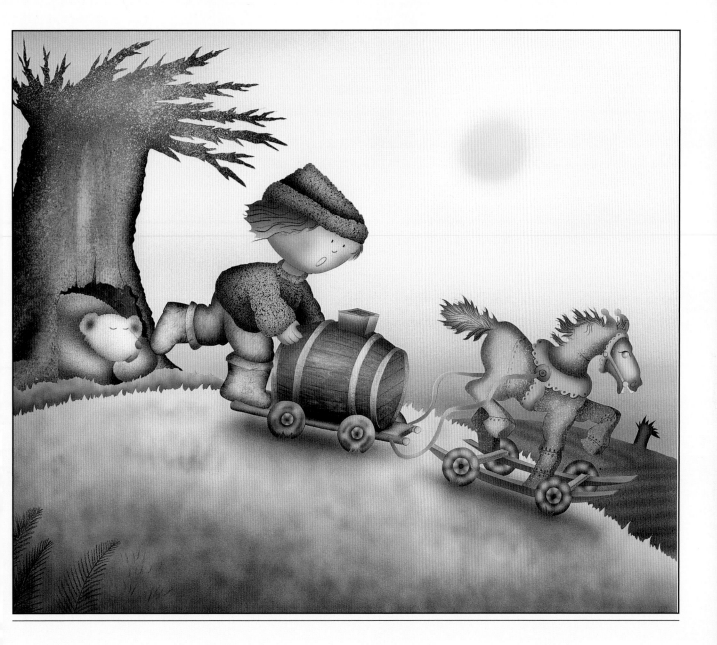

And I am careful not to wake the bear.

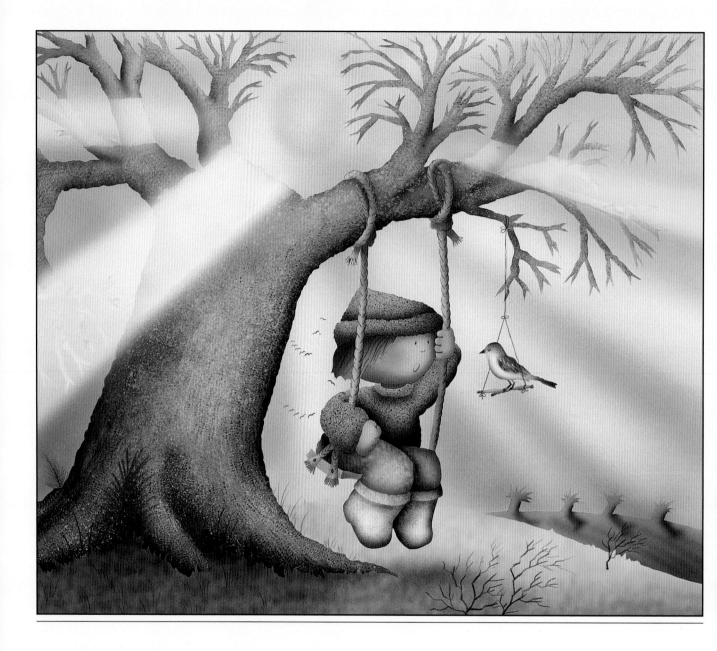

I like to swing in my favorite tree.

Best of all . . .

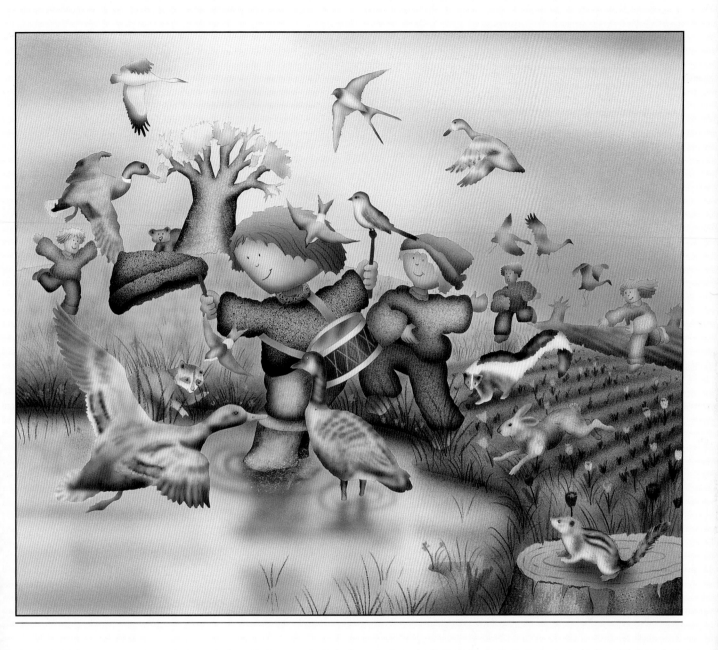

I love spring when I play

outside with all my friends.

Simon
in Summer

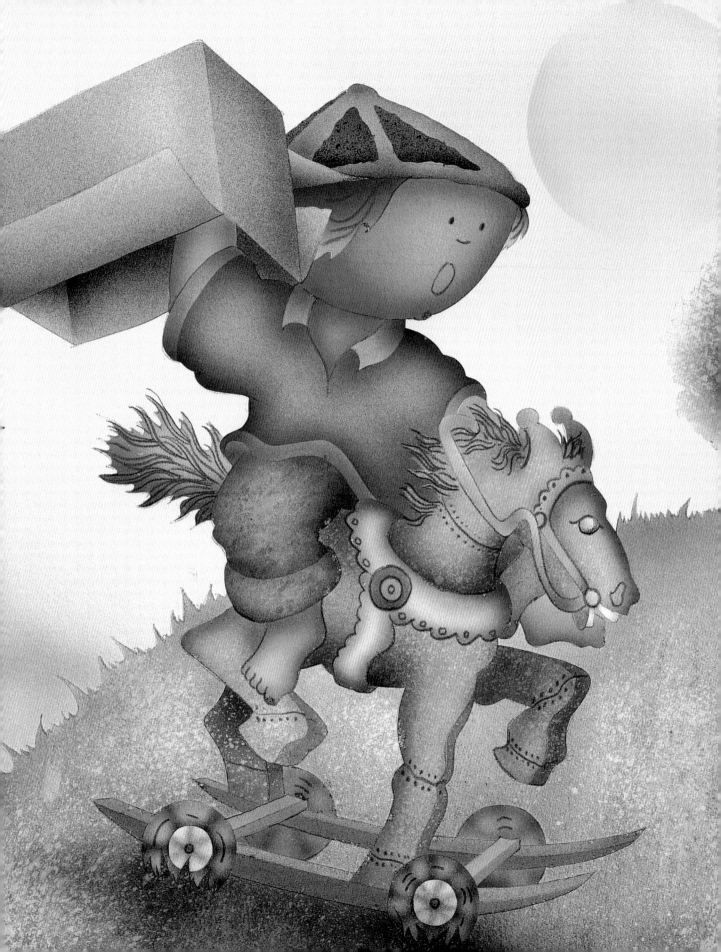

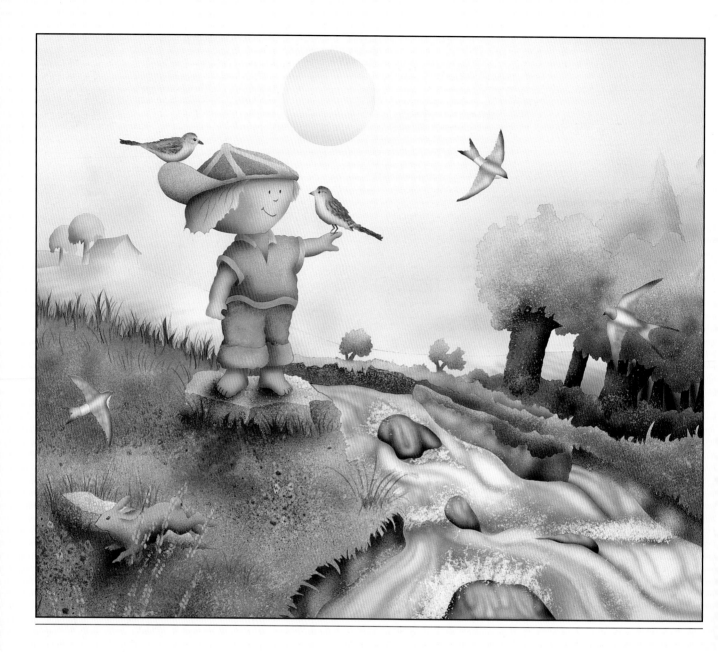

I love summer when the sun is warm.

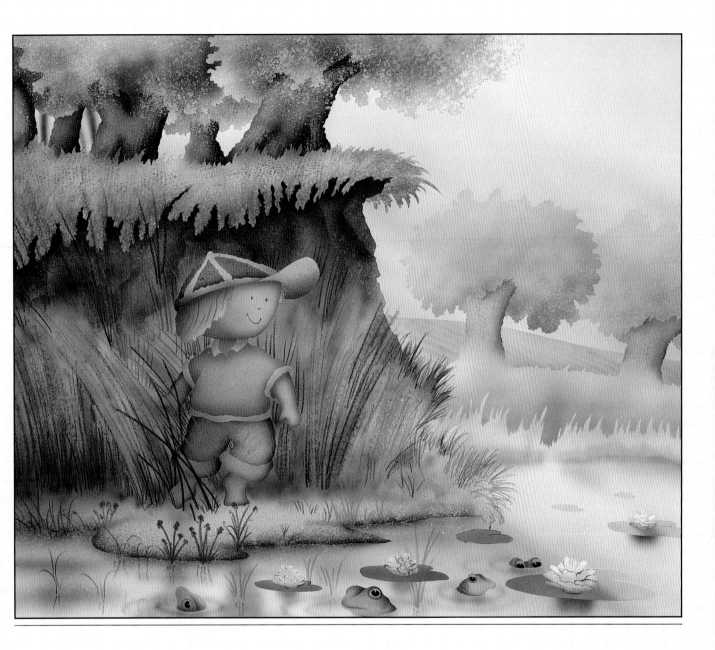

I go to the pond to greet the frogs.

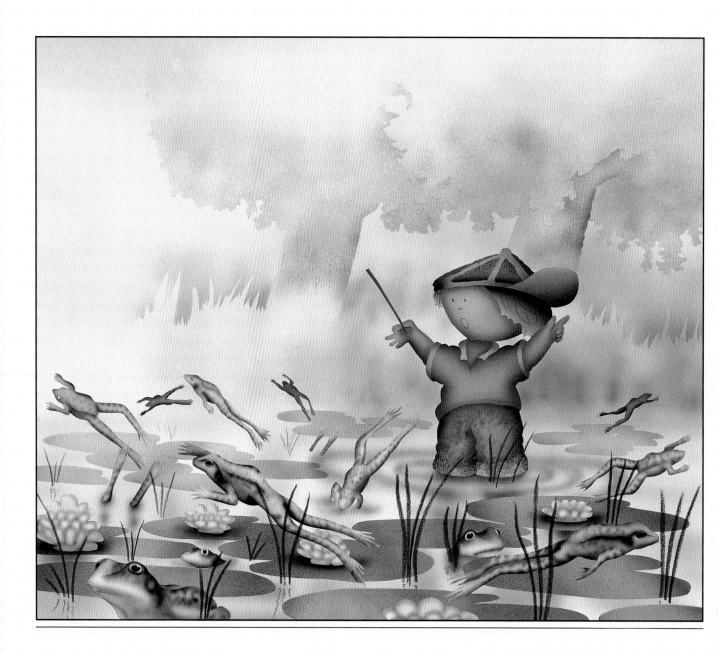

I conduct a froggy chorus . . .

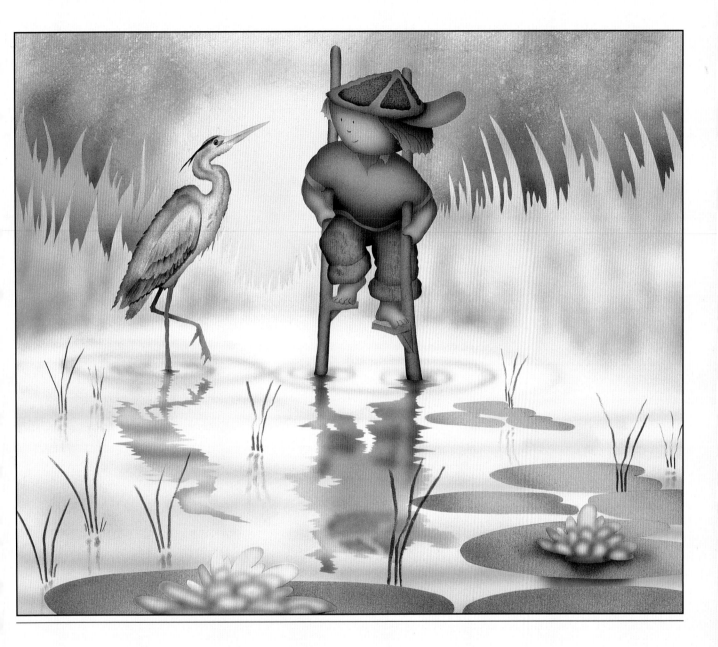

and walk on stilts.

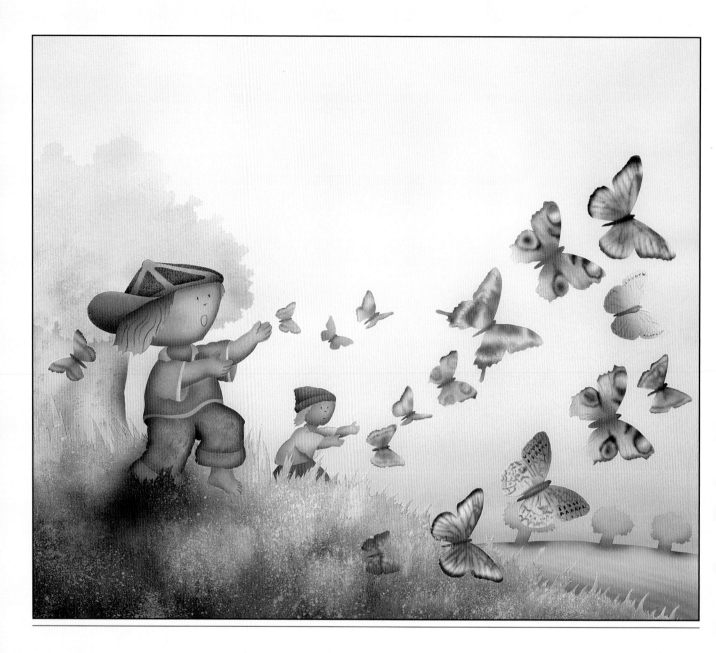

Marlene and I chase

butterflies in a meadow.

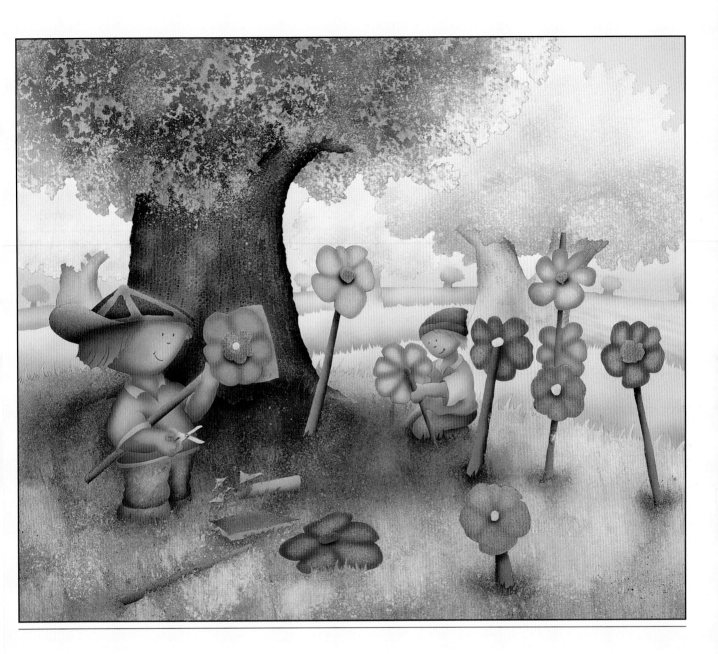

We make giant flowers
to please the butterflies.

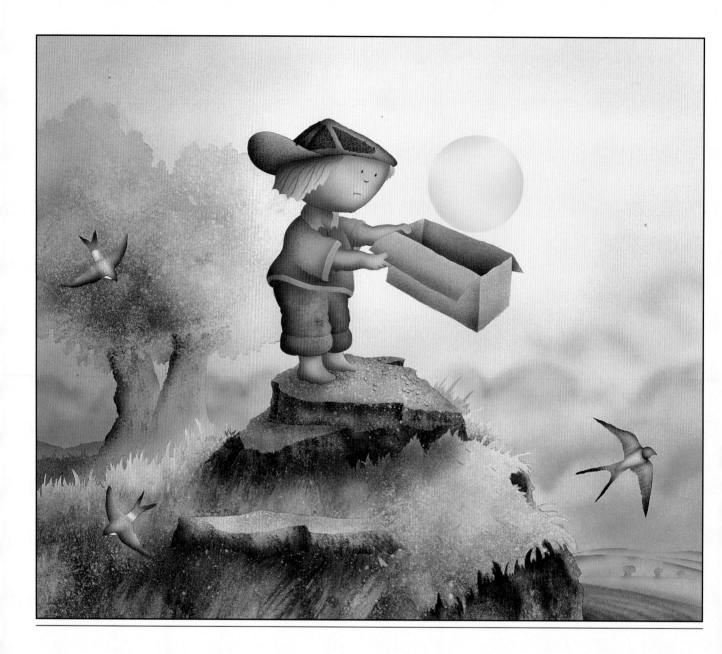

In the summer,

I love to try to catch the sun . . .

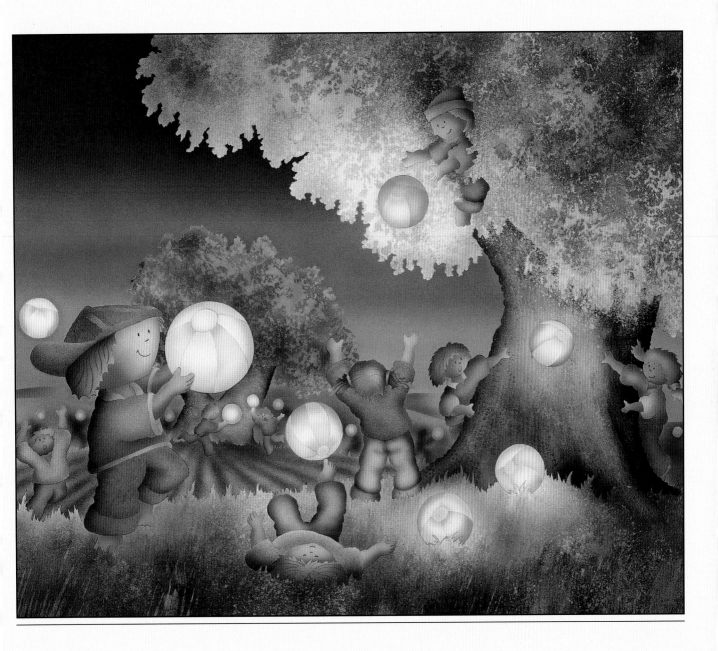

to share with my friends

when they come home.

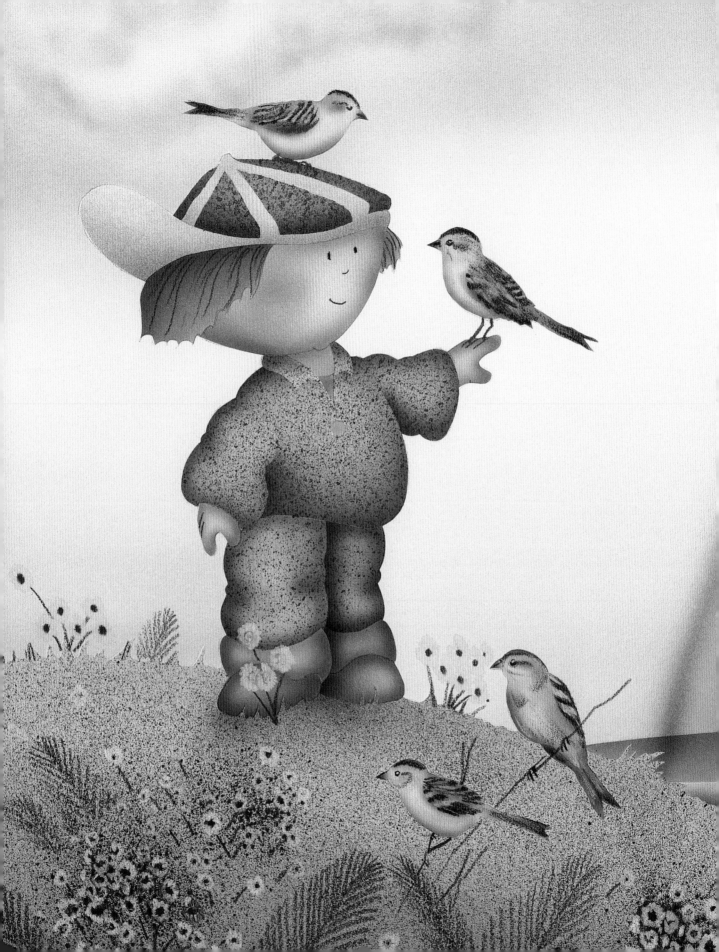

Simon
in Autumn

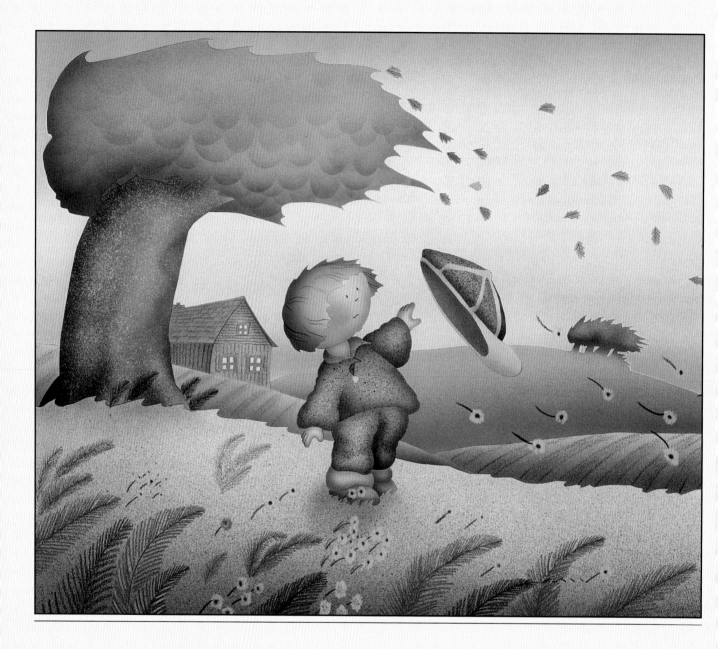

I love autumn

when the wind begins to blow.

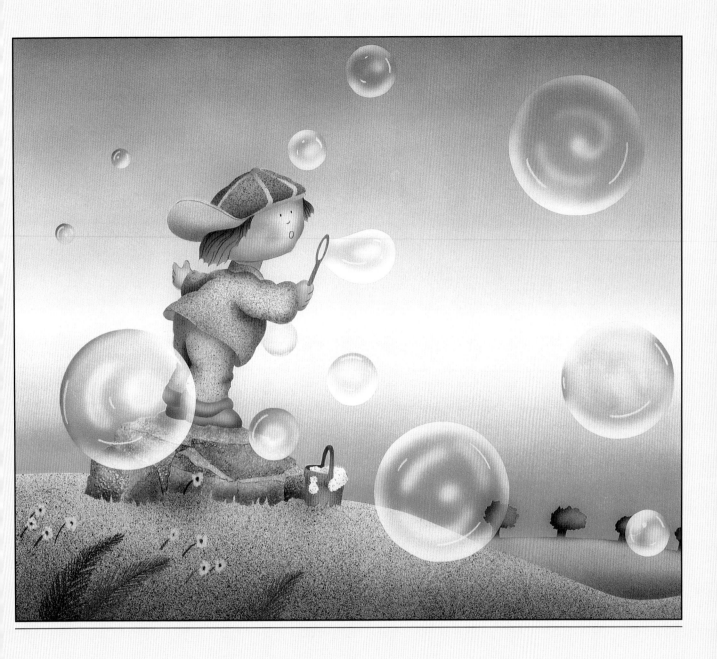

I blow bubbles that fly.

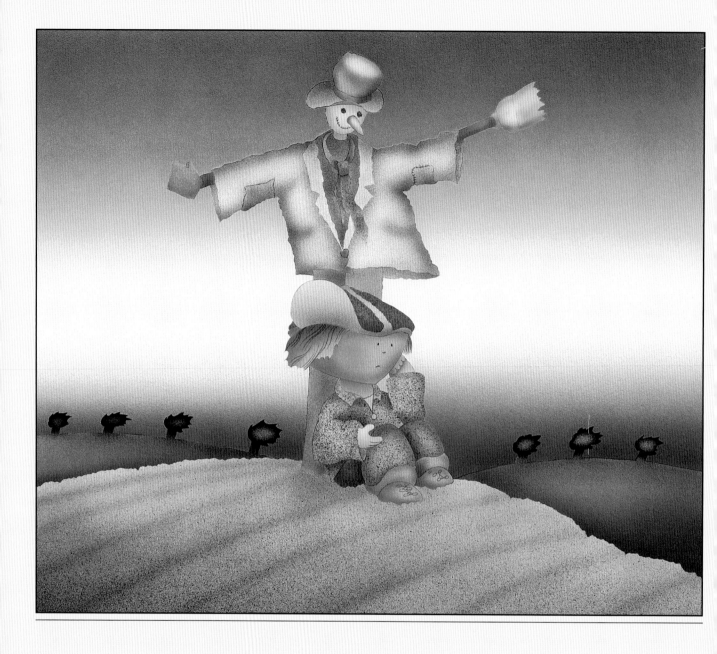

I visit the scarecrow

in the harvested field . . .

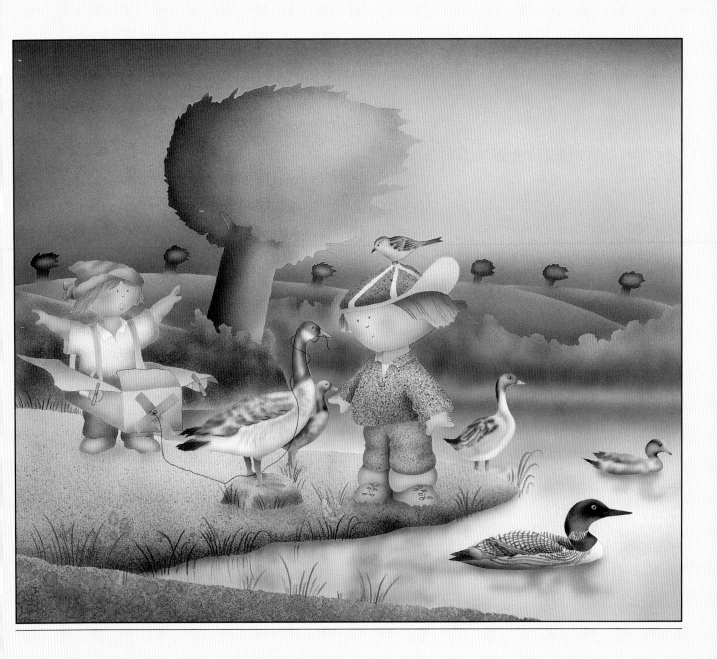

and say good-bye to the birds. I wish we
could go with them in Marlene's airplane.

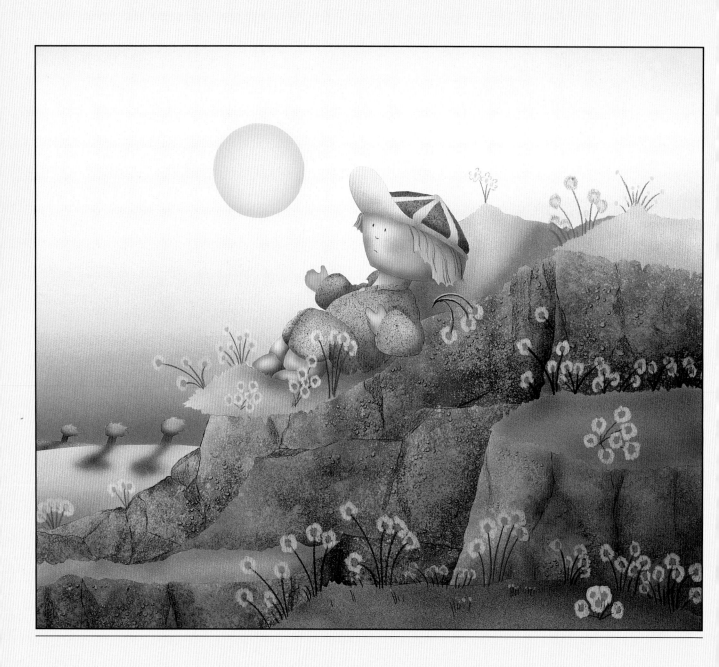

Instead I climb a hill, sit under
the sun, and imagine I can fly.

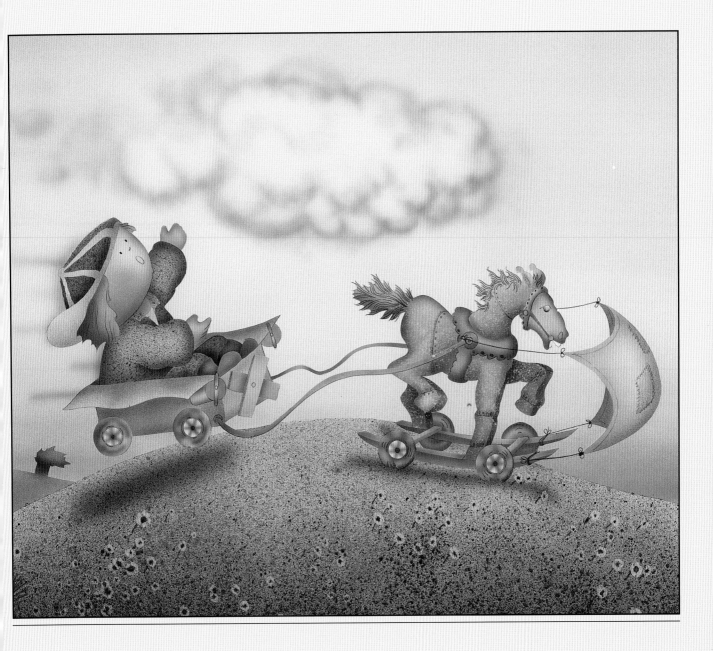

But chasing clouds up in the sky

is always much more fun . . .

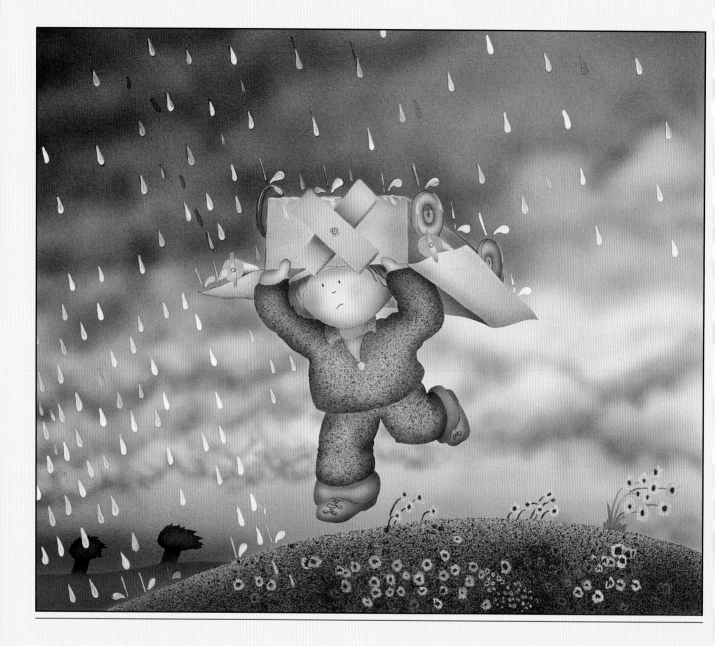

until the rain begins to fall.

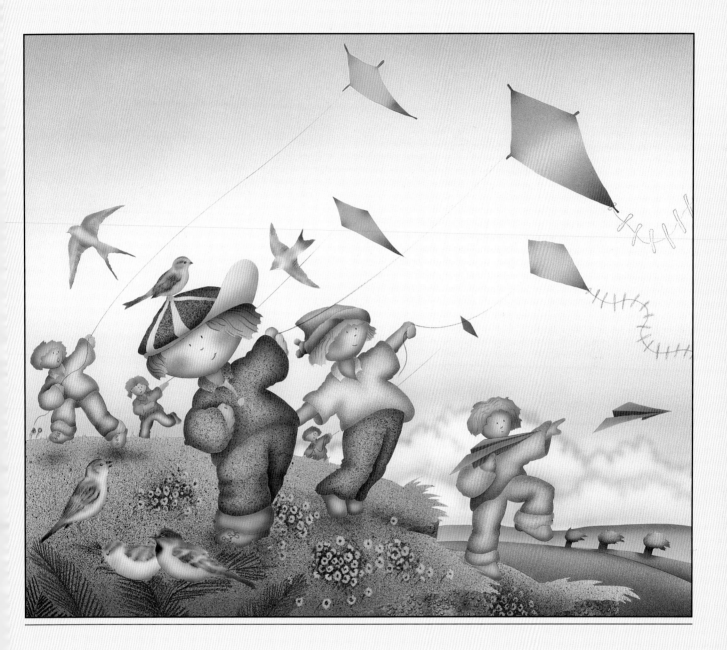

Soon, the sky clears, and I can fly after all!

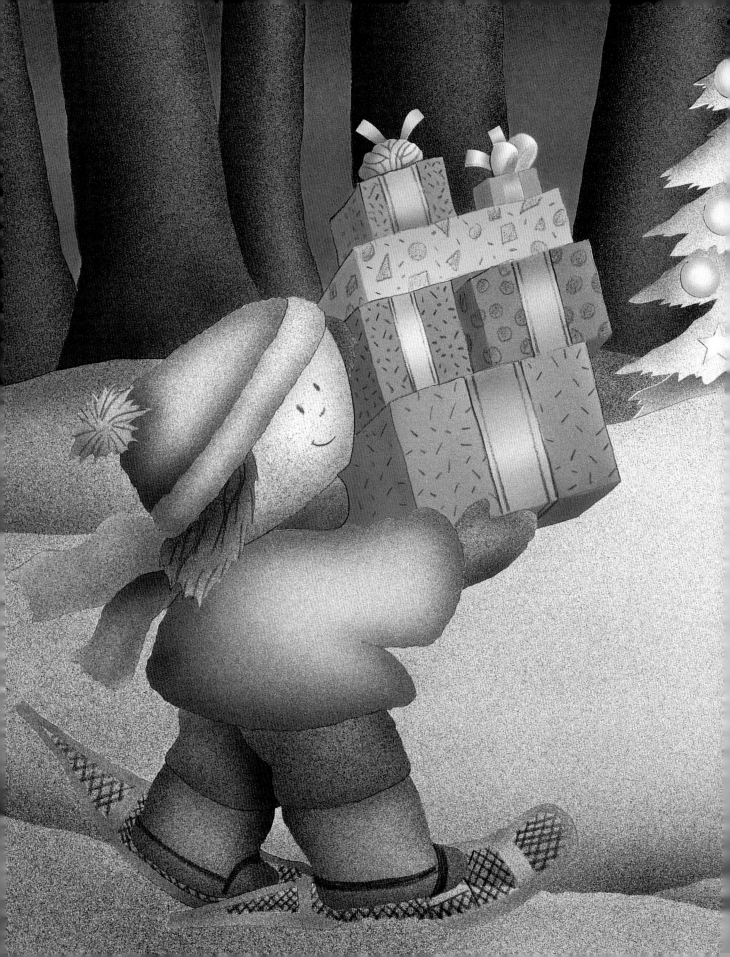

Simon
in Winter

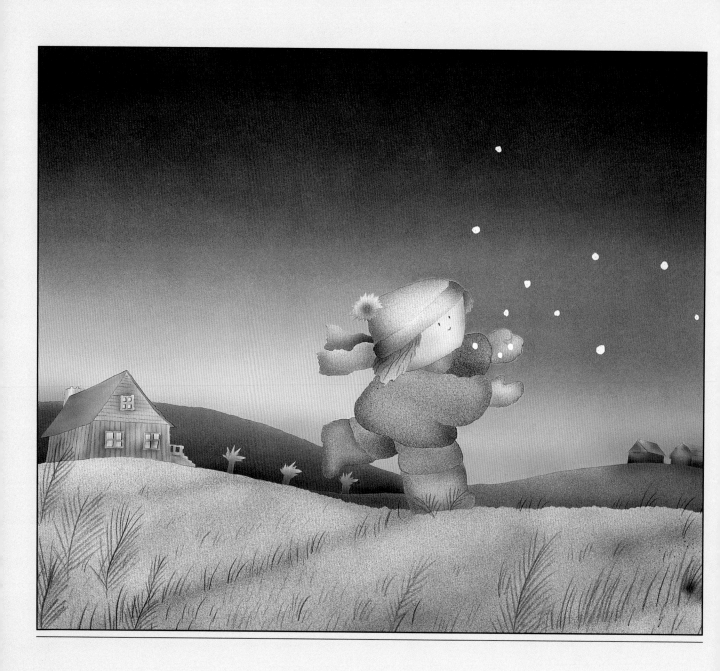

I love winter

when the first snow begins to fall.

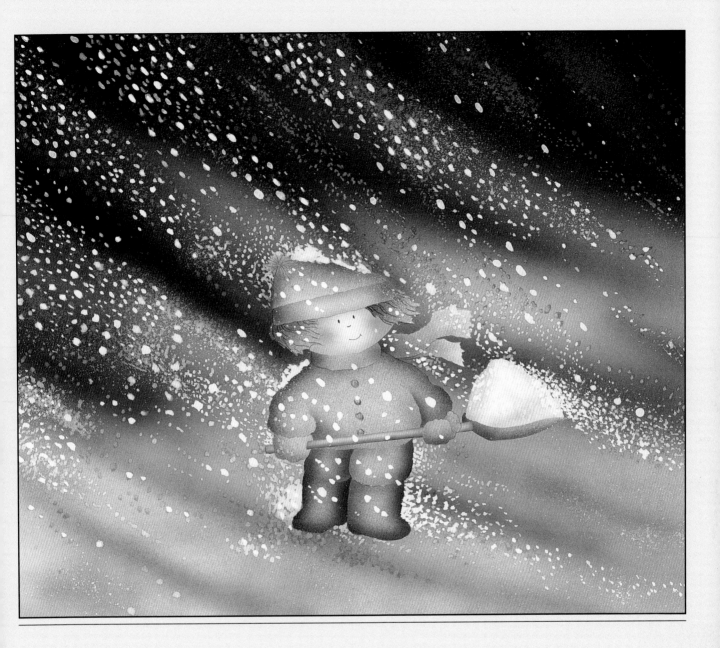

I try to count the flakes,

but they fall too fast.

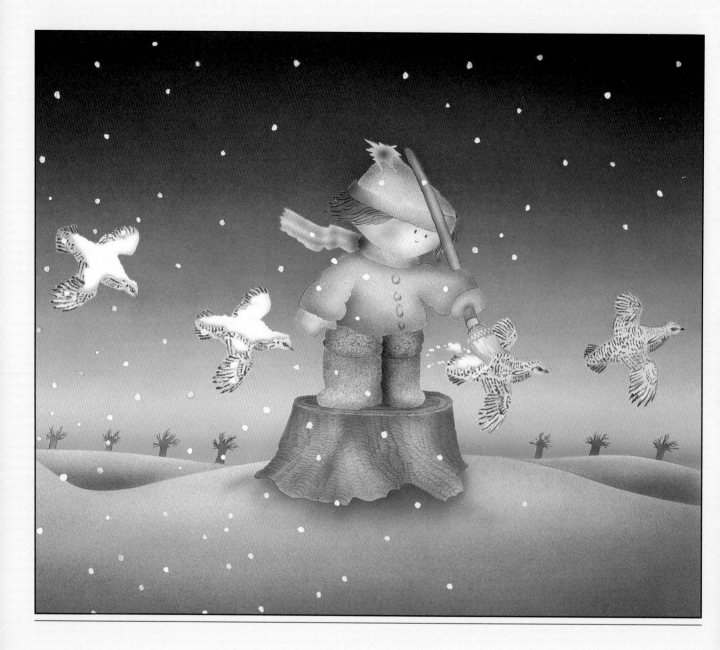

If I count the flakes that fall on a bird

and then count all the birds. . . .

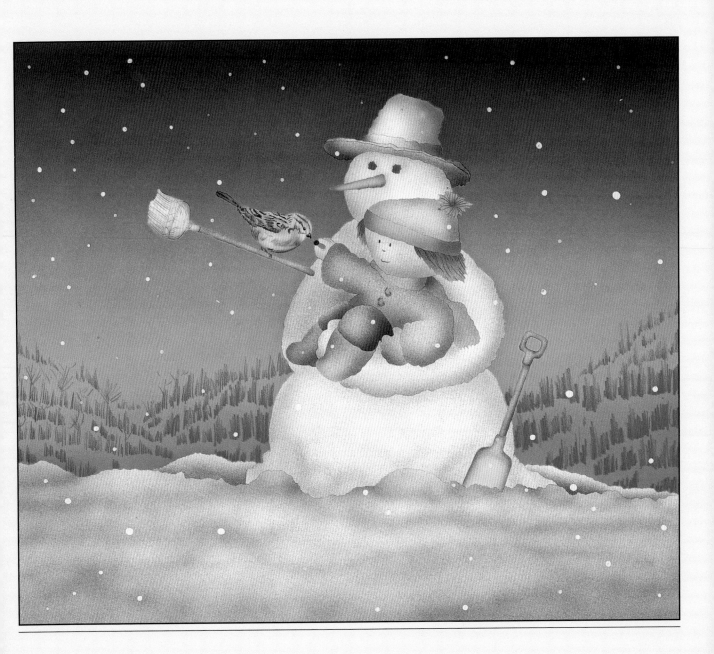

How many flakes

are in a snowman?

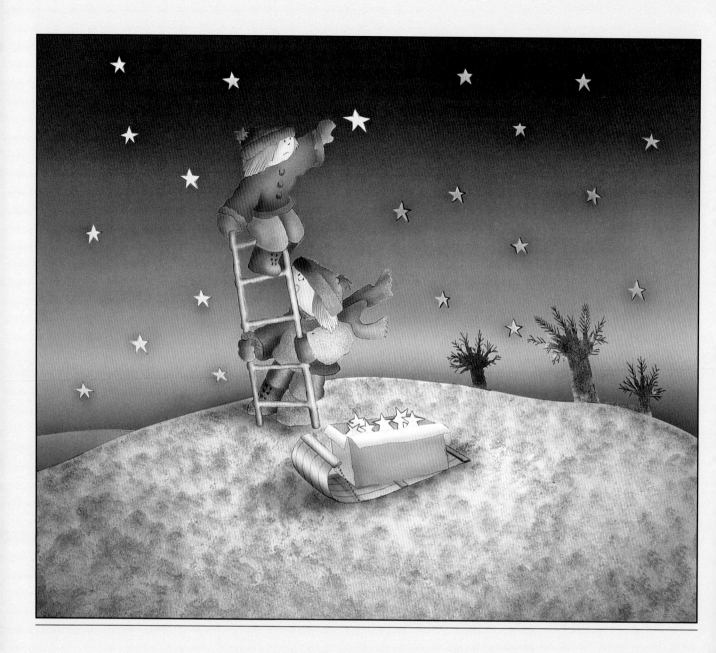

As many as the stars in the wintry sky?

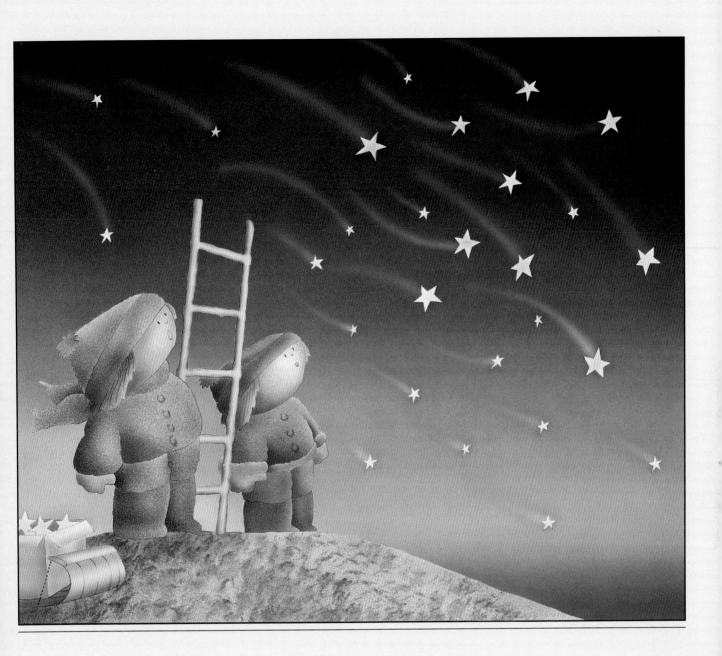

Marlene and I try to count them,

but the stars shoot away into the night.

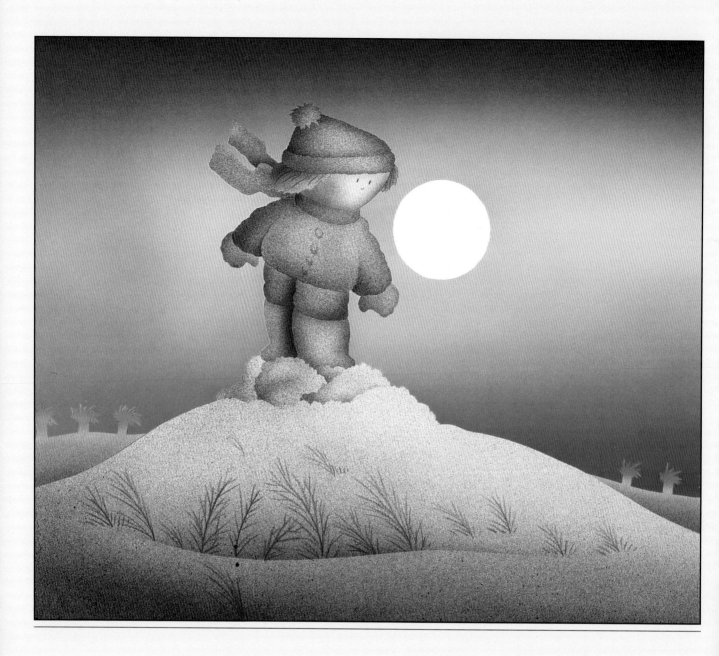

I play in the countless snowflakes.

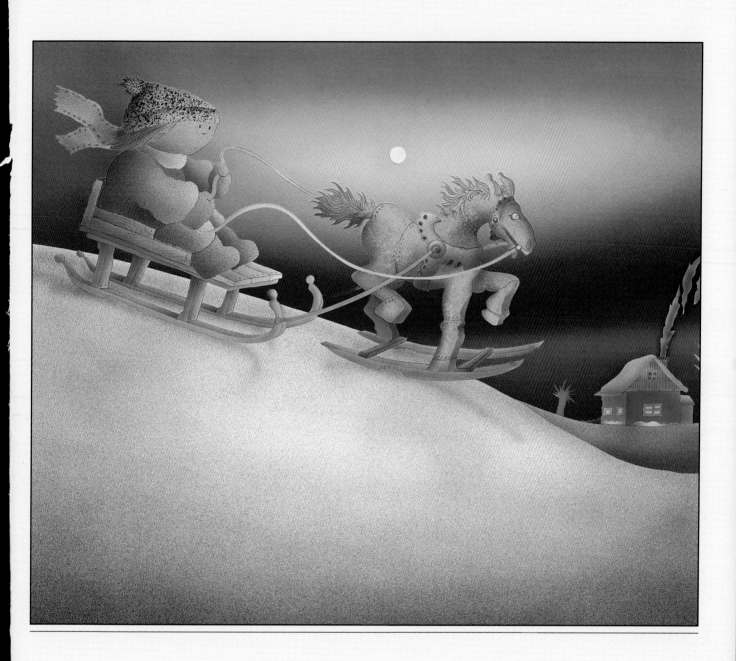

And ride my sleigh all the way home.

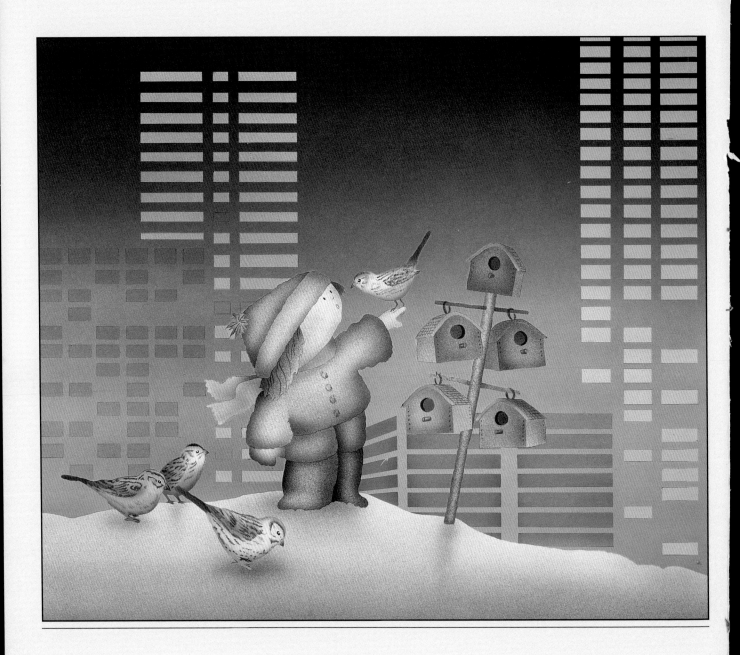

I can't count the stars in the sky

or the flakes in a snowfall . . .

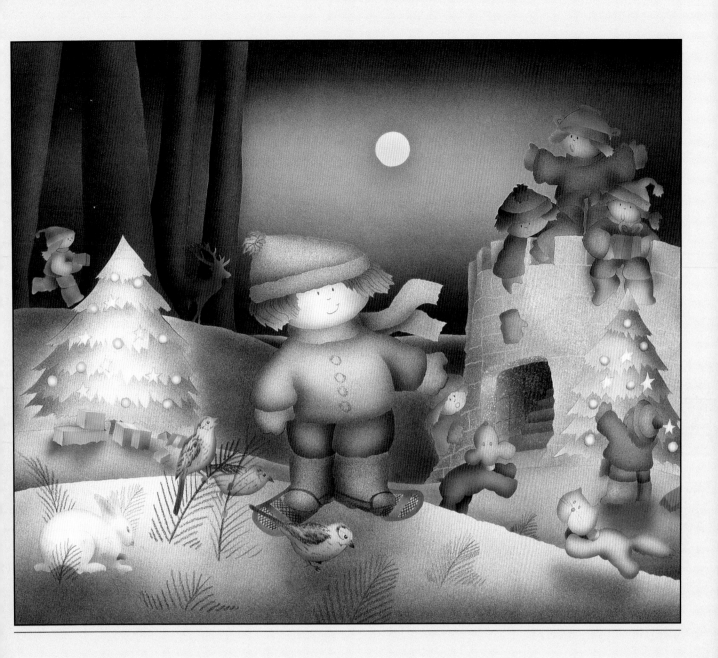

but some things I *can* count . . .

like my friends.

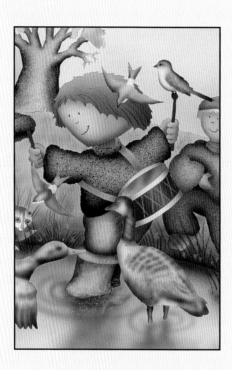